1

Faces and Features

The head is neither a sphere nor a cube, but, rather, a form made up of varied planes and surfaces. Every head—male or female, young or old—is unique. In spite of the differences, however, all heads do have some things in common: two eyes, the nose above the mouth, an ear on each side of the head, and so forth.

Although no two heads are identical, a plan or "formula" for drawing the head is shown on page 5. This general "map" of the face shows the approximate location of the features in relation to each other; however, the shapes and sizes of the features will vary with each individual: a long or short nose, a large or small mouth, close- or wide-set eyes, etc.

Study your subject's head before starting to draw. Look at it from all angles, even from the back. Then ask yourself these questions: Is the face square-, oval-, or heart-shaped? Is it angular or soft? Which feature is most prominent? What are the outstanding characteristics of the model's face?"

Don't start to paint until you are completely satisfied with your drawing (paint will not make a poor drawing better). Then use the best materials available; the better your tools, the easier it is to do a good job. Also, paint with the largest brushes you can comfortably handle and control. Use a 12" x 16" canvas and paint the head about three-quarters life-size. Try painting a head using only burnt umber and white. This is an excellent way to learn to see the lights and darks as they relate to each other.

—Fritz Willis

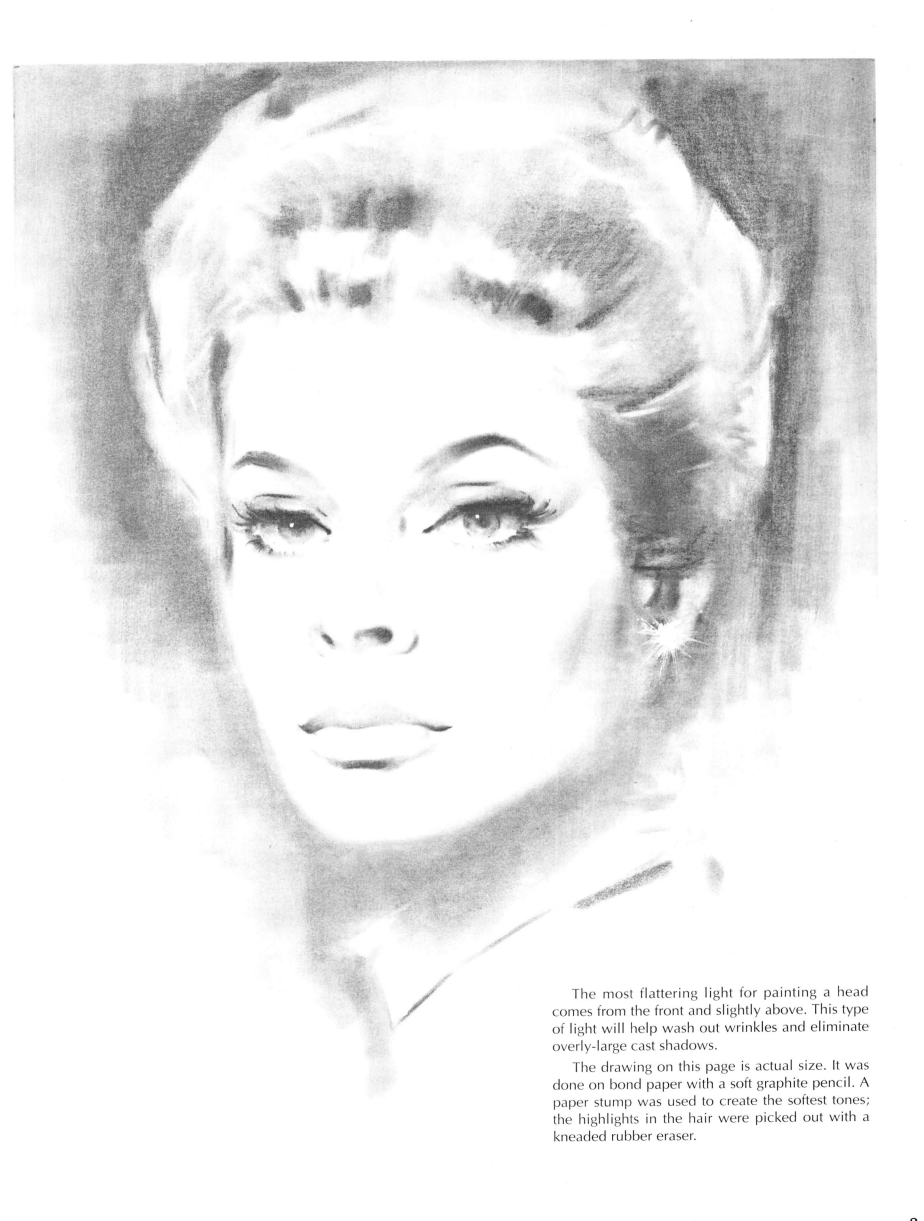

The most flattering light for painting a head comes from the front and slightly above. This type of light will help wash out wrinkles and eliminate overly-large cast shadows.

The drawing on this page is actual size. It was done on bond paper with a soft graphite pencil. A paper stump was used to create the softest tones; the highlights in the hair were picked out with a kneaded rubber eraser.

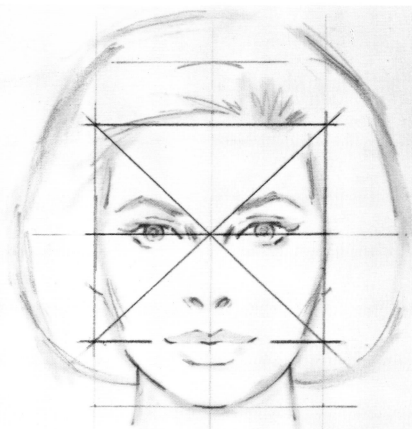

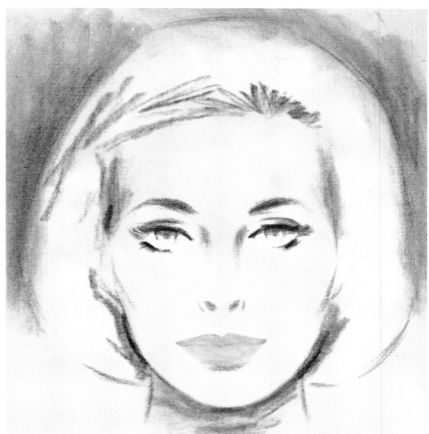

These drawings demonstrate the placement of the features within an imaginary square. Note that the width of the face at the cheekbones is the same as the distance from the hairline to the center of the lips. The line of the eyes is in the middle of the square, and the tip of the nose is halfway between the eyes and the lips.

In this drawing, the guidelines have been erased and color has been added to the lips, face, and background with pastel pencils. Bond paper makes an excellent surface for pastel pencils; it comes in pads of various sizes and has an excellent "tooth" or texture. Also, its tough surface permits erasing without damage (we all have to erase sometime!).

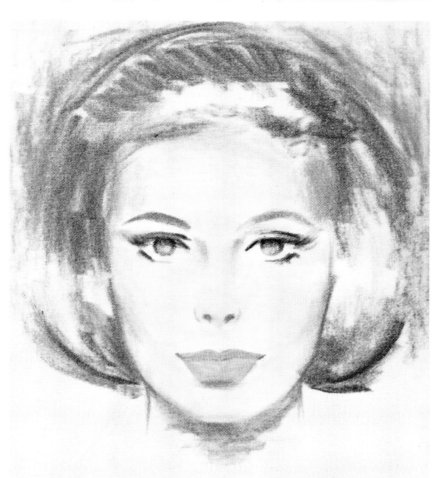

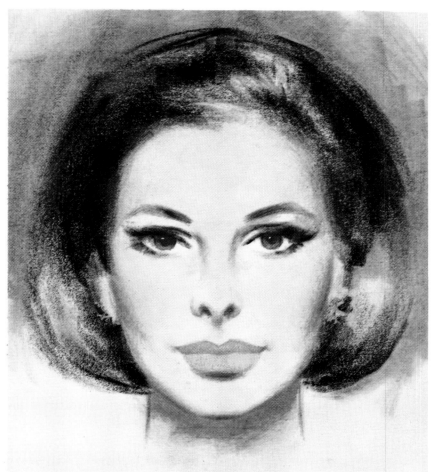

At this stage, tone and color have been added to the hair, and more color and value have been indicated on the face and background. The sketch is now less of a line drawing and more of a tonal or value sketch.

This is the finished sketch. It was done as a preliminary drawing for a painting which was later executed in oils on canvas. Having the sketch for reference makes it easier to complete a finished painting.

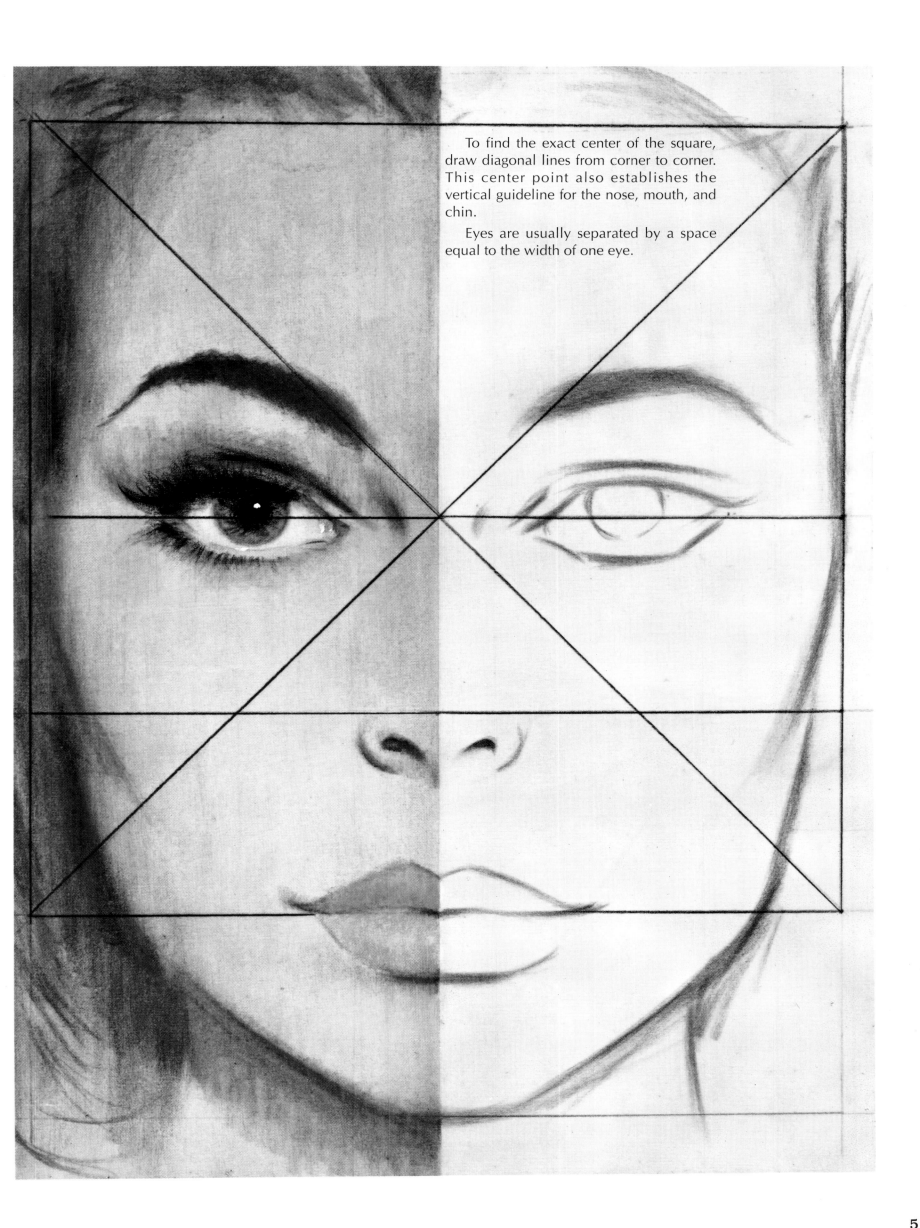

To find the exact center of the square, draw diagonal lines from corner to corner. This center point also establishes the vertical guideline for the nose, mouth, and chin.

Eyes are usually separated by a space equal to the width of one eye.

The arrangement of the large light and dark shapes in a drawing or painting is known as the "pattern." The pattern is as important as the composition and drawing.

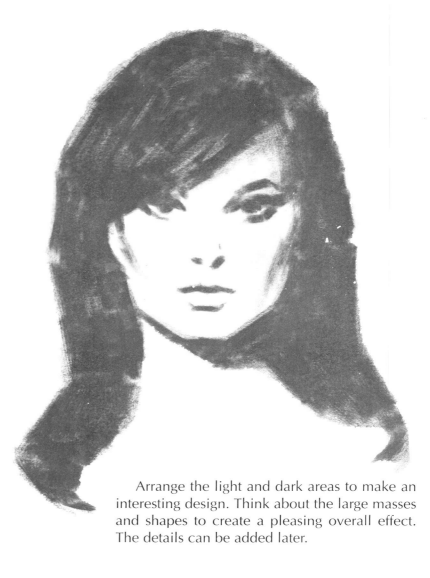

Arrange the light and dark areas to make an interesting design. Think about the large masses and shapes to create a pleasing overall effect. The details can be added later.

Think of the background as a shape surrounding the head. The dark mass of the hair and the light areas of the skin tones also need to be considered when creating the pattern of your picture.

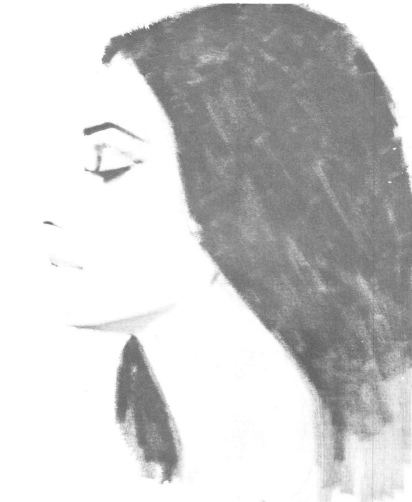

The details of the features are part of the overall pattern effect. This black and white drawing consists of three values: light gray for the skin tones, medium gray for the background, and dark gray for the hair.

Patterns

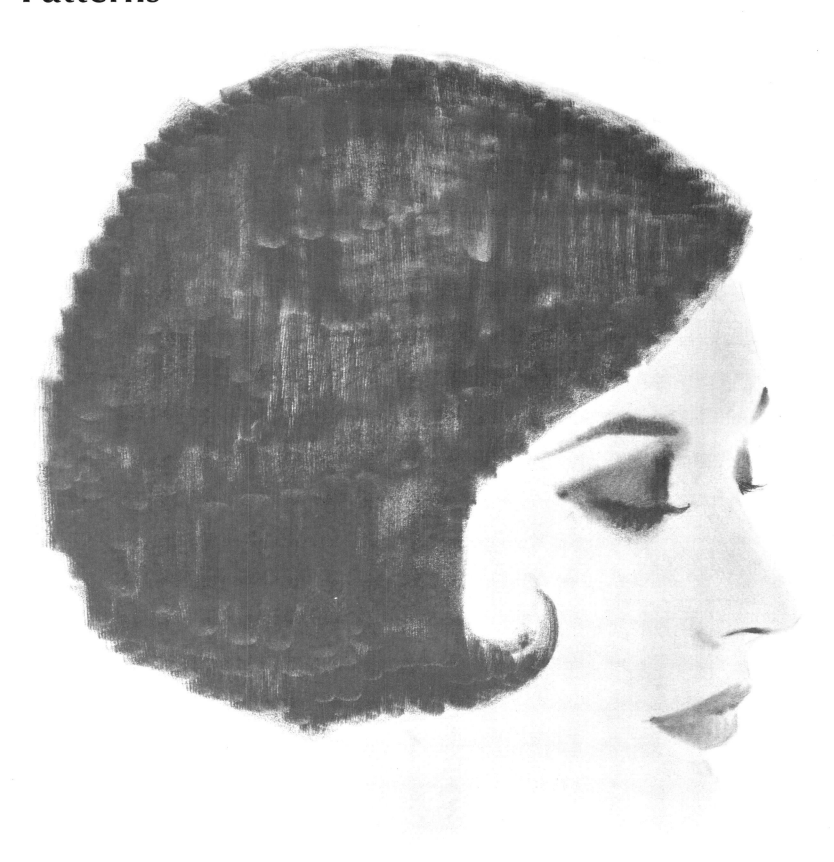

The **pattern** (the arrangement of masses of varying degrees of light and dark) is affected by the way the shapes relate to each other in size and shape.

Intensity is the degree of brightness of a color.

Value is the relative light and dark qualities of a painting or drawing, whether it is in black and white or full-color.

When working in color it is helpful to first do a value sketch in black and white to establish the pattern of your painting. Also, your drawing should not be an island in a sea of white paper; it should fill the entire sheet.

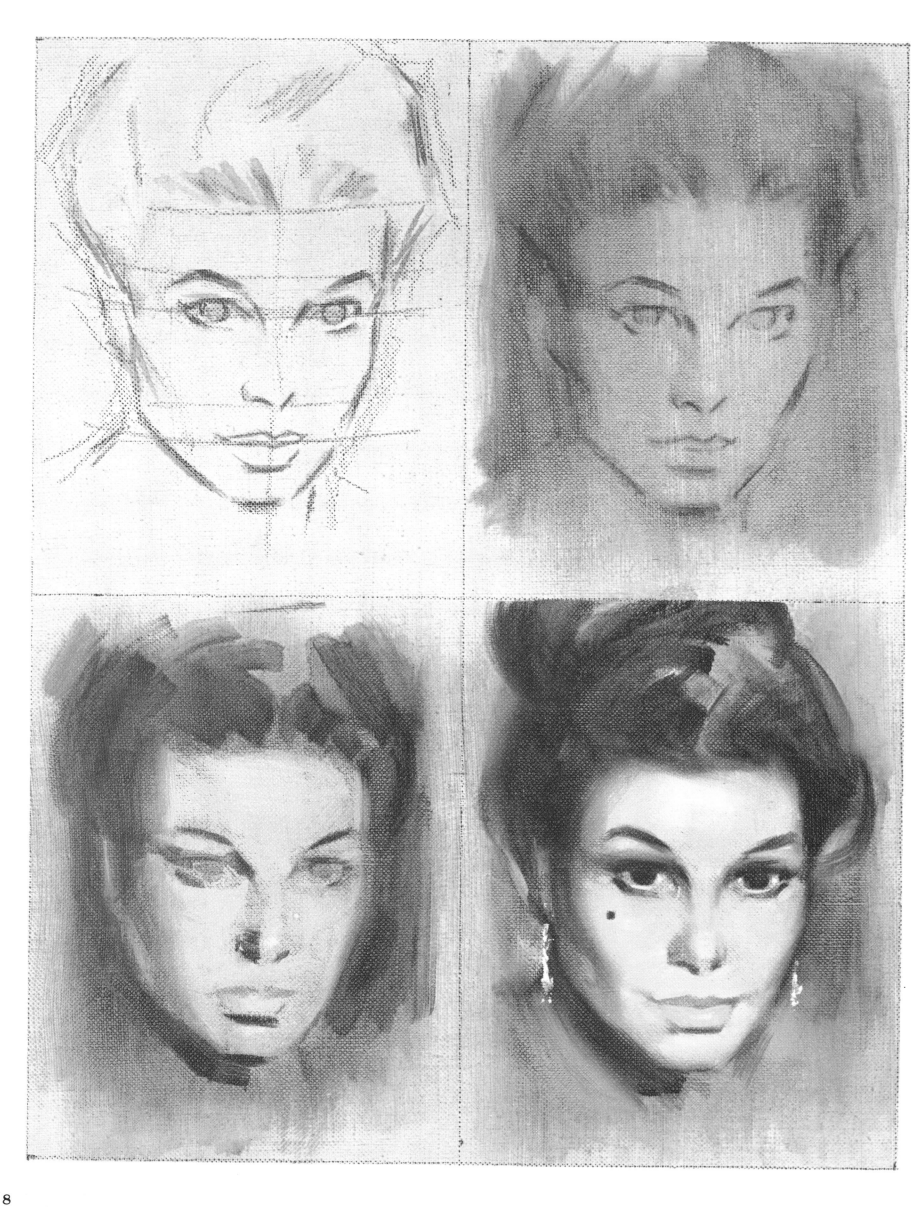

Burnt Umber and White

Burnt Sienna and White

Raw Umber and White

Raw Sienna and White

The head on the opposite page is painted with a limited palette of burnt umber, burnt sienna, raw umber, raw sienna, and titanium white.

Starting with a light gray-toned canvas, the drawing is roughed in using burnt sienna and a #5 pointed sable brush. After the drawing is completely dry, a transparent tone of burnt umber thinned with linseed oil and copal painting medium is laid on using a #20 flat sable brush.

The next step is to lay in the local flesh color in the face. The flesh color is a mixture of burnt sienna, raw sienna, and white. The dark mass of the hair is painted with pure burnt umber.

In the finished painting, the pink of the lips and cheeks is made with a mix of burnt sienna and titanium white. Although burnt sienna is a rather fiery color when used straight out of the tube, the addition of white makes beautiful silvery-pinks.

The grays in the background near the hair are a mixture of raw umber and white. It may look brownish on your palette, but when used next to burnt umber, it will give the effect of cool gray.

As you can see, the finished painting has an almost full-color look even though it was painted with a limited, monochromatic palette.

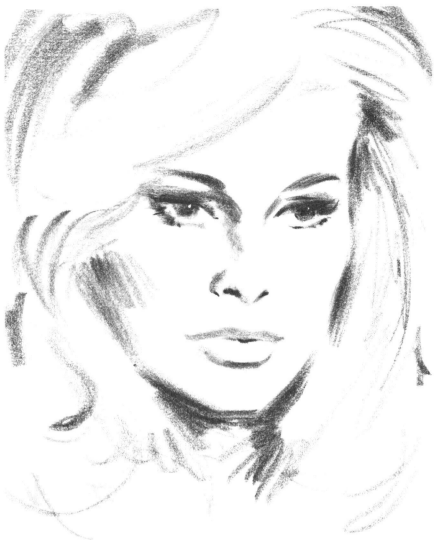

In this head, the bone structure is quite evident with the well-defined jawline and cheekbones and the rather deep eye sockets. The soft treatment of the hair framing the face accents the angular feeling of the face's outline.

It is easier to capture a likeness when working from a model who has definite characteristics.

Notice the different personalities of these two drawings. The rounded forms and soft shadings on the head below contribute to the innocence and softness of the individual, while the angles of the drawing above add to its firmness and maturity. Keep in mind that angled lines that are drawn too sharply create a hard look, changing the entire personality of the model.

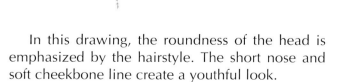

In this drawing, the roundness of the head is emphasized by the hairstyle. The short nose and soft cheekbone line create a youthful look.

It is best to give a casual or indefinite look to the hairstyle. A stylish hair-do may look great at the time of the painting, but it might look totally out-of-date a few years later, thus dating the painting.

This is a more mature, sophisticated head. The high cheekbones, heavier eyelids, and formal hairstyle give a degree of elegance to the head.

The sidewise glance and angle of the head help to suggest the woman's sophistication.

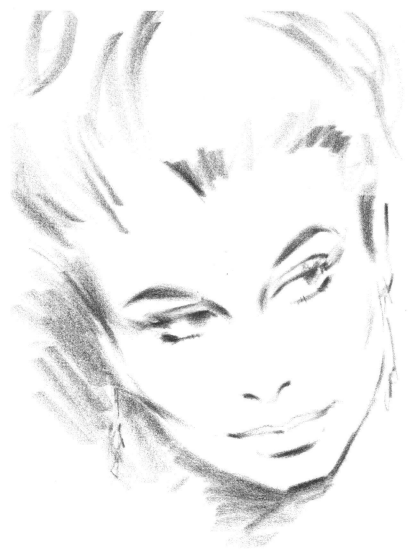

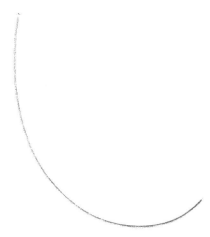

Notice how the different treatments of the background in these two drawings adds to the mood of each model. If a roughly-drawn background was used on the lower drawing, it would greatly alter the personality of the model. However, if a smooth, dark background was used for the top drawing, it would enhance the depth of sophistication of the model.

This drawing captures a combination of innocence and sophistication. The short, round nose and soft facial lines are in direct contrast to the full lips, generous mouth, and dark-lashed, mysterious look of the eyes.

Although this subject has an oval face which is usually associated with youth, the prominent features create a provocative look.

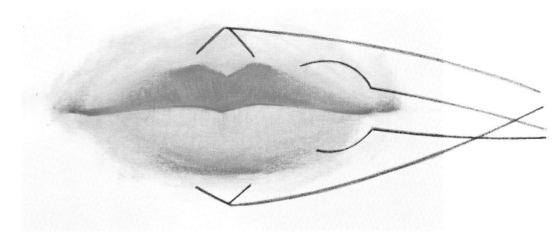

Hard edges are left in these areas.

Soft edges are created in these areas.

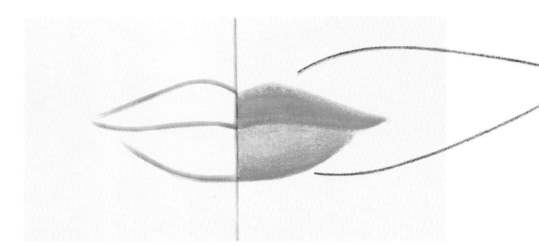

Warm pink (cadmium scarlet and white) is used on the upper lip.

Cool pink (alizarin crimson and white) is used for the lower lip.

Hard edges all around make the lips look as if they are "pasted" on.

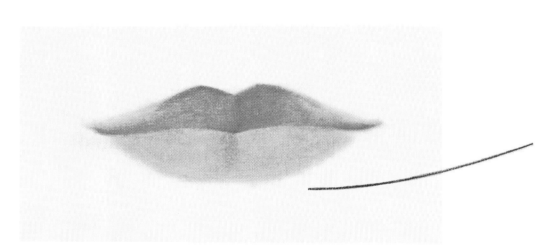

A mixture of venetian red and white is used for natural-colored lips.3

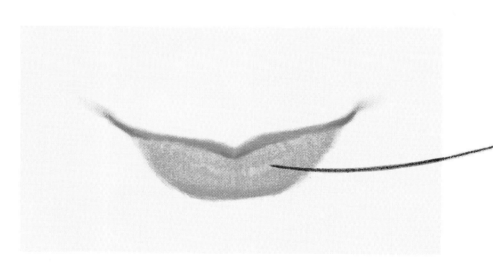

Use pale pink rather than white for the highlight on the lips.

A small, thin-lipped mouth gives a severe look to the face. If your model has this kind of mouth, I suggest that you widen the mouth and make the lips somewhat fuller.

Soften the edges of the lips, blending the lip color into the surrounding flesh tones so they won't appear to be pasted on. It is all right to have a well-defined line at the center of the mouth, but be sure to soften the edges toward the outside corners.

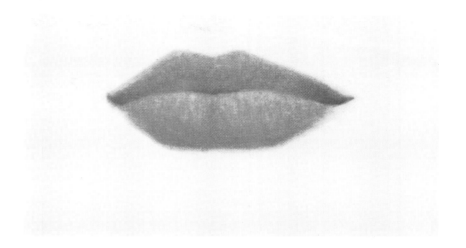

Don't make the lips too red or they will have an artificial, "painted-on" appearance.

A mixture of venetian red and white makes a good natural color for lips. If you want more warmth in the lips, add a bit of cadmium scarlet.

The upper lip should be slightly warmer in color and darker in value than the lower lip. A mix of alizarin crimson and white makes a good cool pink for the lower lip. Add cadmium scarlet to warm the color for the upper lip.

Use alizarin crimson for the darkest accents in the corners of the mouth and at the separation between the upper and lower lip.

Don't make the highlight on the lips too bright. A white highlight will make the lips look greasy; for a moist look, use a pale pink.

The defined angles of the chiseled nose denote maturity and elegance. The softer, rounder nose is typical of youth.

In the mature head, the bone structure of the nose is more evident, and the part of the nose directly between the eyes is narrower than it is in youth. Also, the space between the eyes is greater in a baby's face.

In a youthful head, the nose is shorter with softer, rounder planes and, often, a slight upward tilt at the tip. Take care not to tilt it too much or the nose will look like a "snout." Treat the nostrils delicately without emphasis.

Unlike the eyes and mouth, the nose is practically immobile and has very little to do with the expression of a face. It is, however, an important feature for establishing the character and nature of the model and capturing a likeness.

The nose and ears continue to grow throughout life; a long nose and large ears are an indication of age. Noses of the very elderly tend to droop at the end.

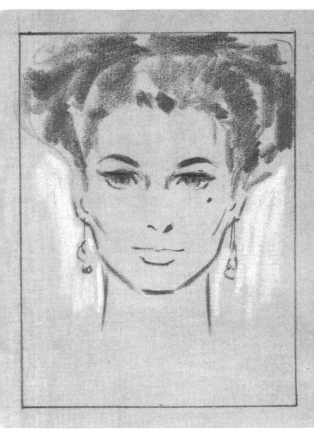 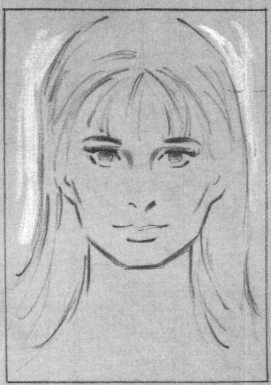 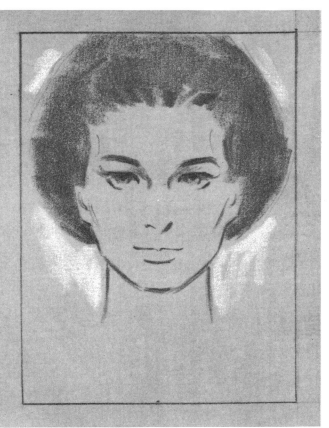

These six drawings have the same basic head with different hairstyles. Changing the hairstyle affects the model's entire character. Hairstyles change every few years and an extreme hair-do will date your painting. Some women are inclined to accept the fashion of the day without considering whether it is becoming to their particular facial structure.

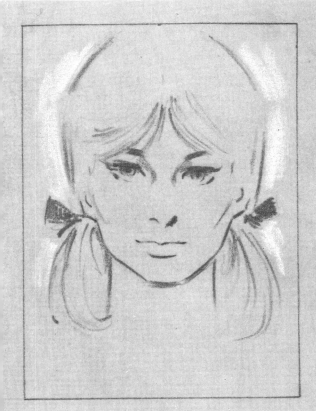 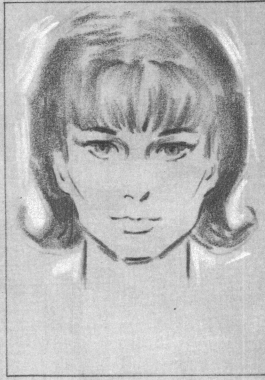 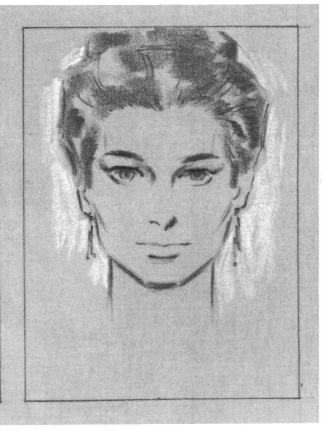

While the hair is an important element of the head and can be used to express elegance or simplicity, maturity or youth, sophistication or innocence, don't let it influence your impression of the model. Style the hair so that it expresses your desired feelings about the model. Make the hair an attractive and interesting frame for the face.

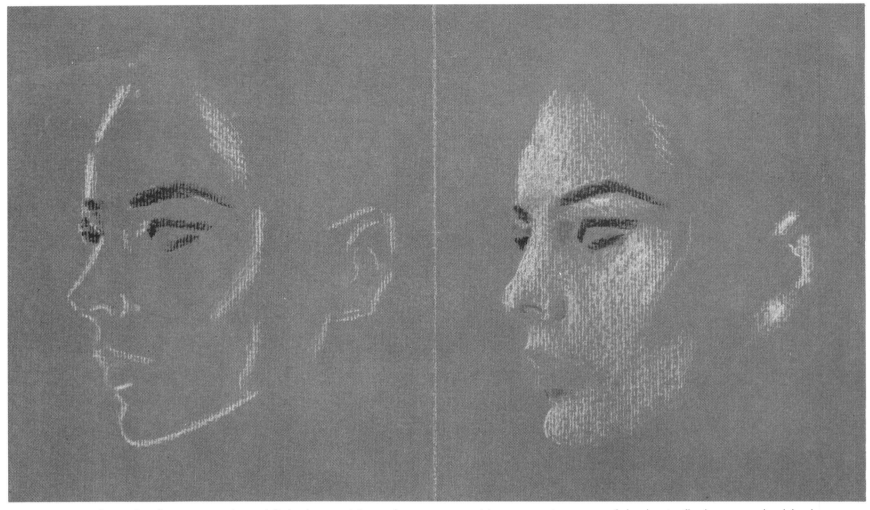

First place the features and establish the position of the eyebrows.

Now mass in some of the basic flesh tones; the blank spaces will serve as shadows.

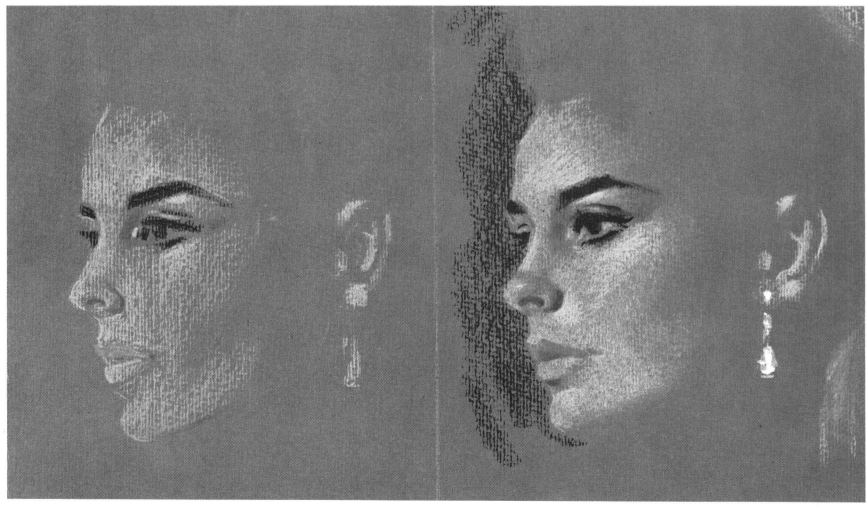

Add the lips and the details of the nose and eyes. Suggest the ear and the earring.

Block in the shadow in front of the face to create depth and to soften the shadows of the face. Add more color to the details: lips, cheek, nose, and eyes.

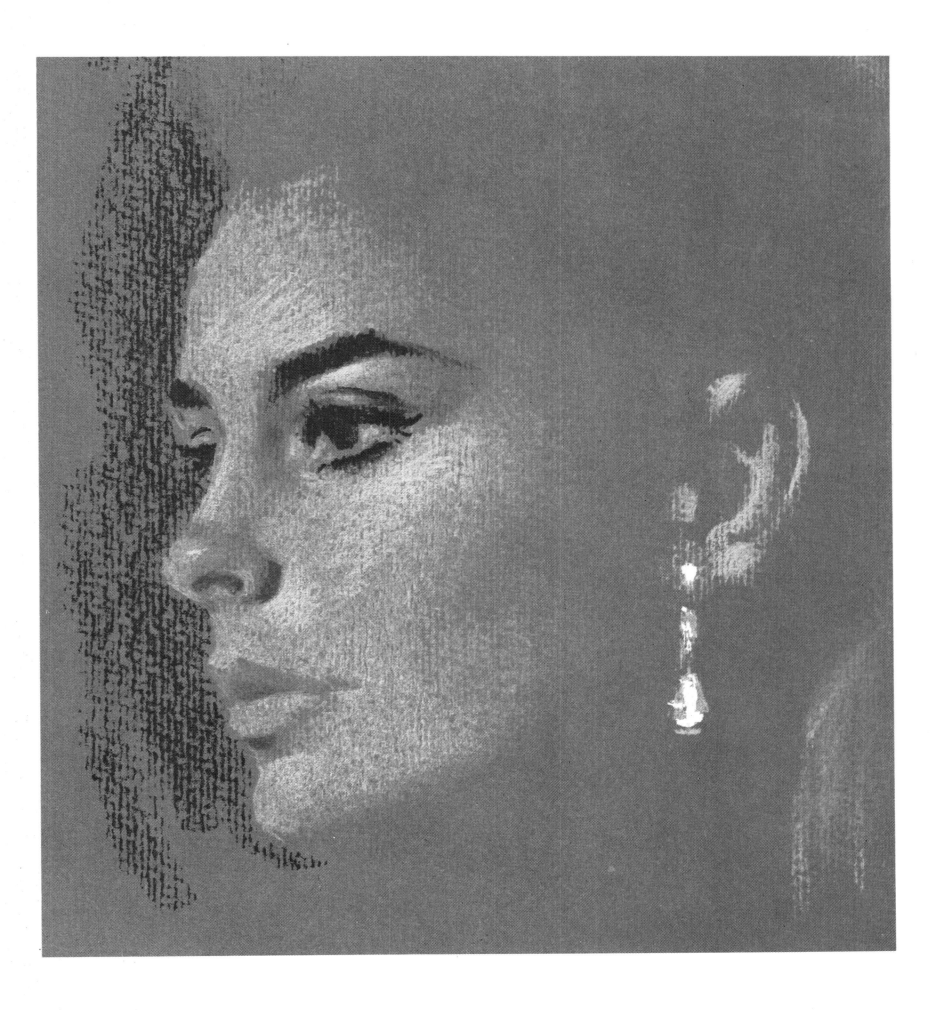

Background is an important part of a painting. However, if the color or pattern is too interesting it will conflict with the subject; if it is too drab or flat in tone there will be no feeling of space and atmosphere between it and the subject. To create a greater feeling of volume and roundness in the head, lighten the background where it meets the dark (shadow) side of the head, and darken the background where it meets the light side. This will also create the impression of space between the head and the background.

1.

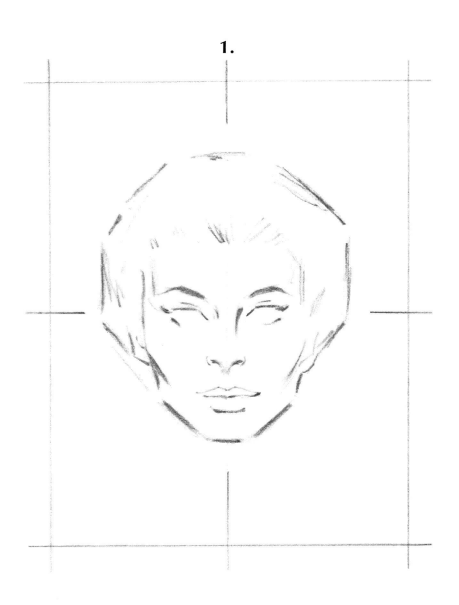

2.

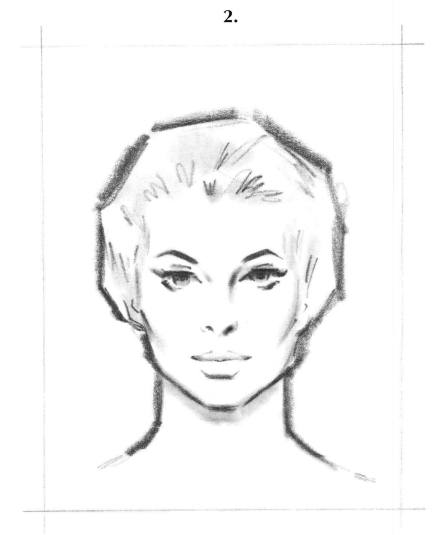

3.

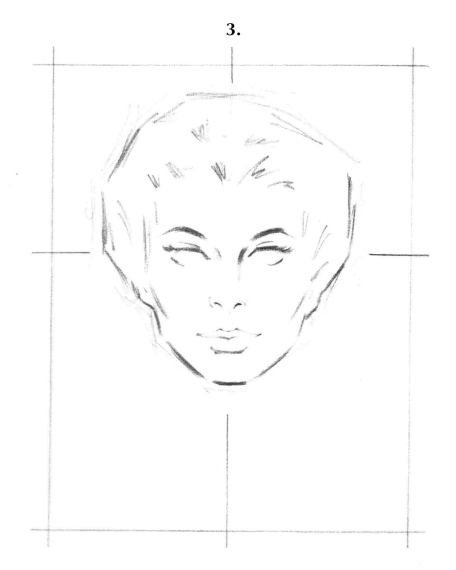

4.

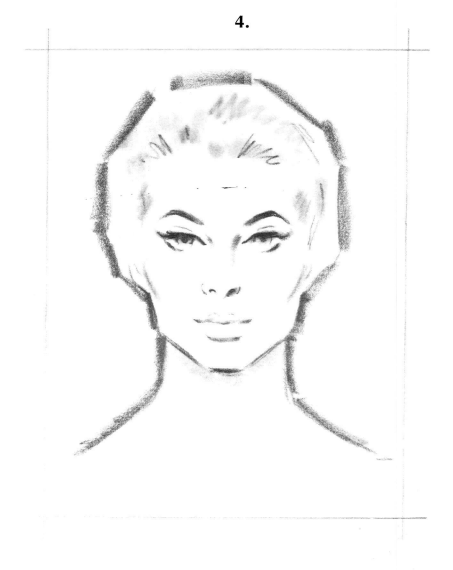

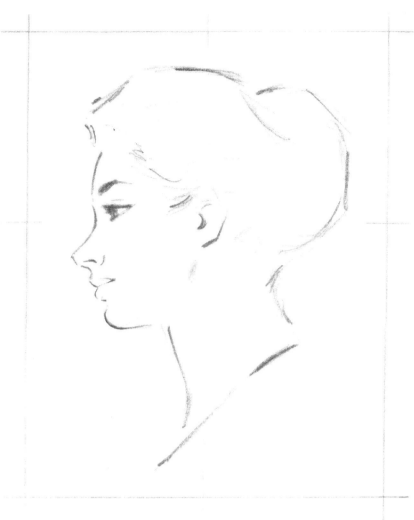

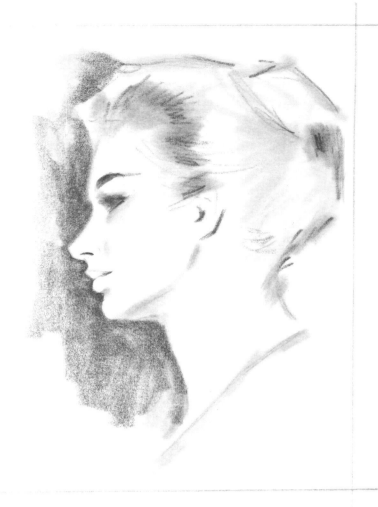

When painting a head in profile, leave slightly more background in front of the model than behind it. In the drawing above, the head is in the exact center of the canvas which makes the space in front too tight.

Here the head has been moved slightly to the right, creating a more pleasing composition. This may seem to be a minor point, but many (otherwise) good paintings have been weakened by the poor placement of subject matter.

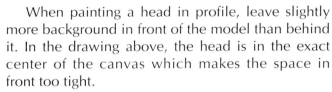

When you are planning a drawing or painting of a head, be sure to work out the proper placement in the beginning. If the head is placed too low, it will appear to be falling through the bottom of the picture plane; if it is placed too high, it will appear to "float."

In drawing #1 on the opposite page the head alone appears to be well-placed in the center. However, when the neck and shoulders are added (drawing #2), it becomes obvious that the composition is too heavy at the bottom.

In drawing #3 the head seems to be placed too high. However, there is plenty of room for the neck and shoulders to support the head. Try to keep the entire subject in mind when planning the composition layout.

In drawing #4 it is apparent that the head is in the proper place for a well-balanced design. Also, even with the neck and shoulders added, there is still enough room at the bottom to support the subject.

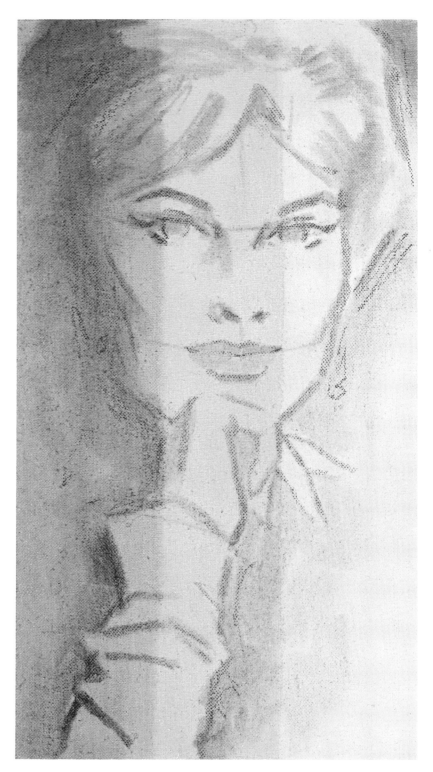

In panel #1 a transparent tone of cadmium green pale thinned with turpentine and a few drops of drying oil (sun-thickened oil or stand oil) is laid over the drawing using a #20 flat sable brush. After this is dry (about 24 hours), a second transparent wash of burnt umber is applied over the first tone and allowed to dry. This first demonstration panel was done in sections to show the color and value of the washes. (In actual practice, the tones are applied over the entire surface of the canvas.)

In panel #2, the pattern of the composition begins to emerge. In nature, shadows are transparent, so the dark areas are painted thinly. As you work toward the light areas, the paint should be applied more heavily. A #20 flat sable and a #5 pointed sable are used with a palette of burnt umber, cadmium green pale, venetian red, yellow ochre and titanium white. This limited palette offers a wide range of flesh tones.

A 16" x 20" canvas is a good size and proportion for painting a head, but don't limit yourself to a particular size or shape. Decide on the pose and make a few preliminary sketches before selecting the canvas. Note the long, narrow composition of the painting above.

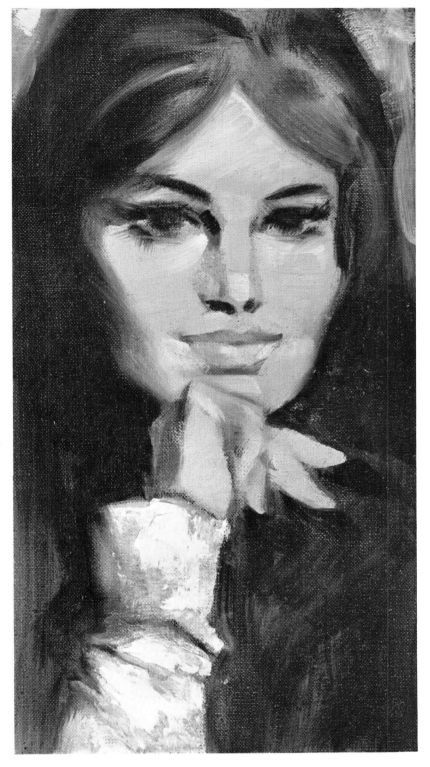

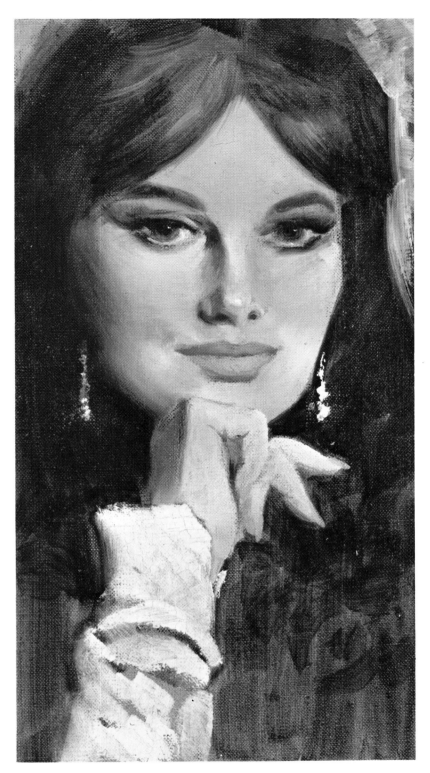

The panel above includes the main dark and light areas. Notice that some of the toned canvas is left uncovered, thus becoming a part of the finished painting. This technique creates an interesting effect.

This is the finished painting. The flesh color is made with venetian red, yellow ochre, and titanium white. The shadow side of the face is blended into the background to give the head roundness.

Burnt Umber

Cadmium Green Pale

Venetian Red

Yellow Ochre

Titanium White

21

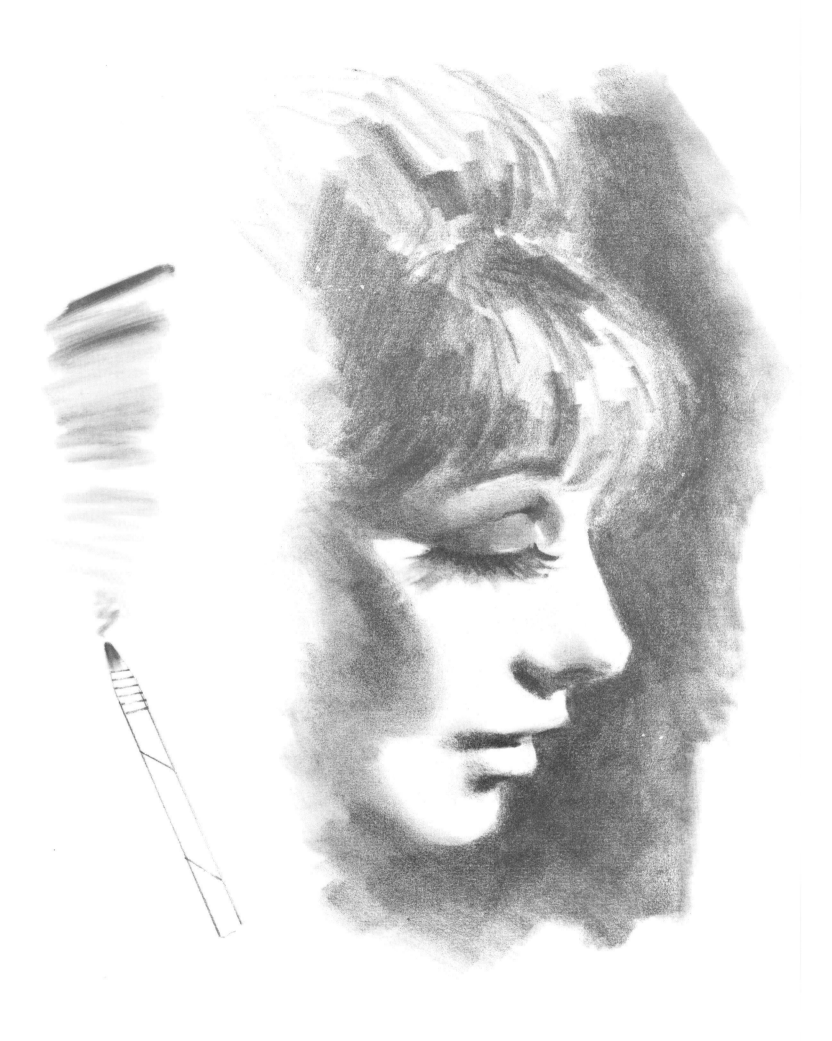

This drawing was done with a soft graphite pencil on vellum tracing paper. After the drawing was completed, a paper stump with the tip dipped in benzine was used to intensify the extreme darks. With practice, many interesting effects can be achieved with this technique.

The rich blacks and soft middle tones create a certain strength and quality that is often missing in the average pencil drawing. Tracing paper, vellum, and bond layout paper are good surfaces for this technique.

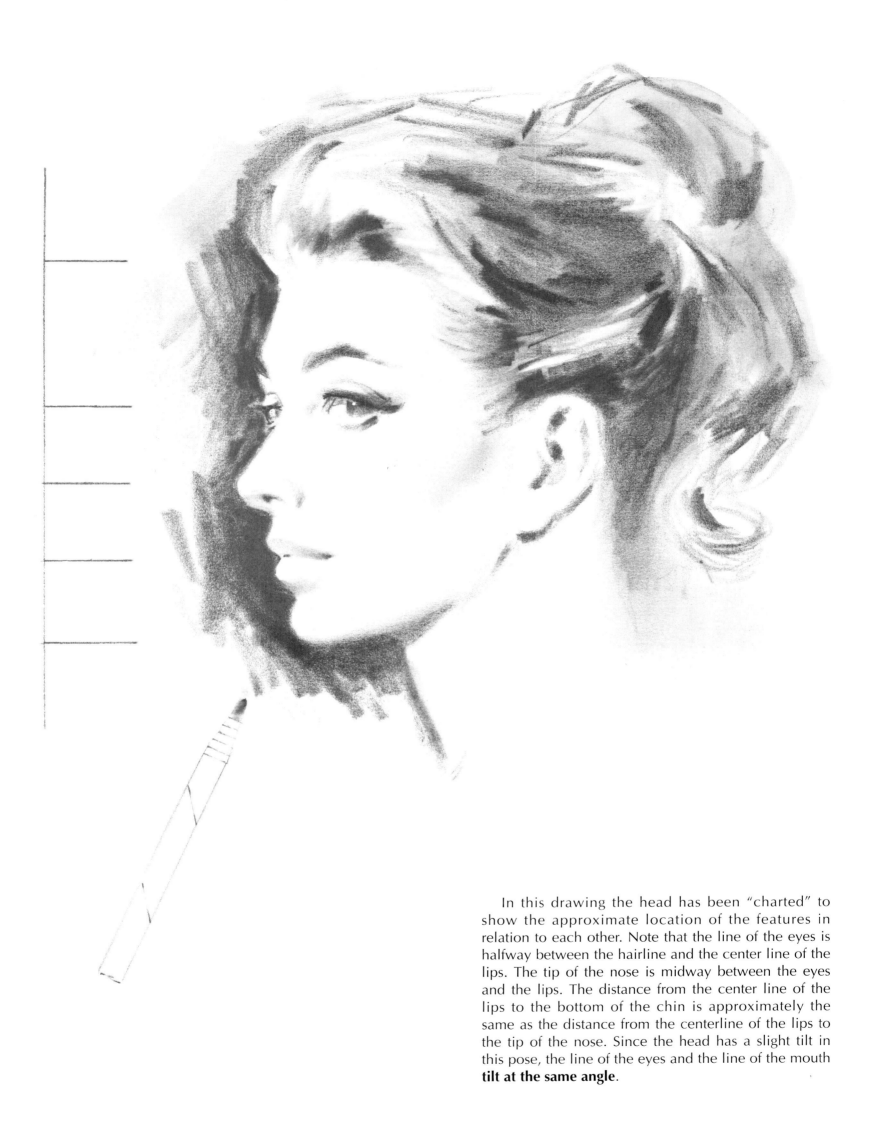

In this drawing the head has been "charted" to show the approximate location of the features in relation to each other. Note that the line of the eyes is halfway between the hairline and the center line of the lips. The tip of the nose is midway between the eyes and the lips. The distance from the center line of the lips to the bottom of the chin is approximately the same as the distance from the centerline of the lips to the tip of the nose. Since the head has a slight tilt in this pose, the line of the eyes and the line of the mouth **tilt at the same angle**.

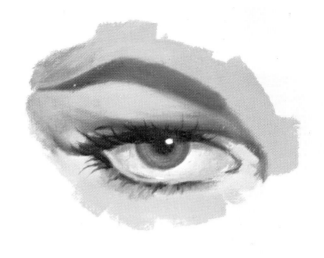

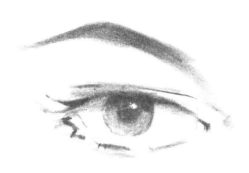

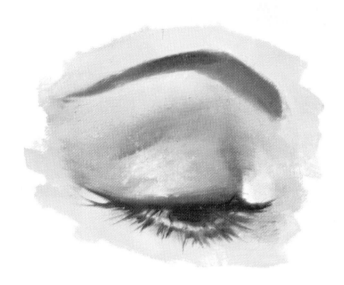

Notice the positions of the upper lids in these different eye expressions. Always allow the upper lid to slightly overlap the pupil and iris. This eliminates a staring and, in some instances, crazed look in the eyes.

The upper lashes are heavier and fuller than the lower lashes, therefore, they appear darker.

The lower lashes become longer and fuller toward the outside corner of the eye.

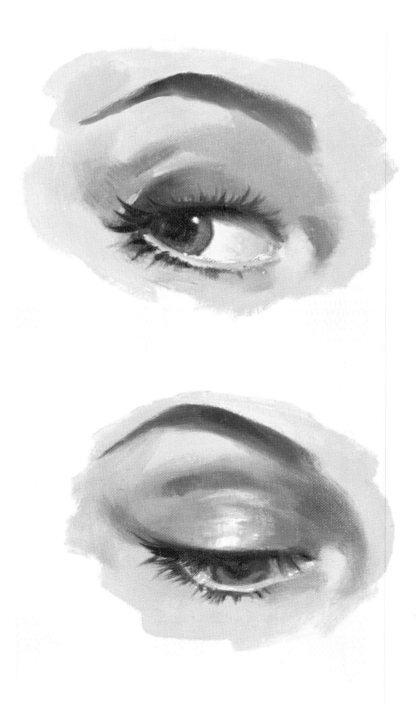

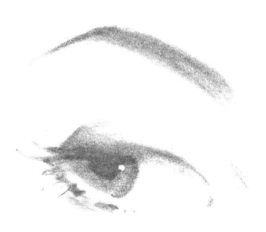

The colors used on the upper lid affect the attitude of the face. Some colors indicate sophistication, but be careful not to overuse bright colors because an overpainted eye may appear clown-like.

When viewing the face straight on, the distance between the eyes is roughly the width of one eye.

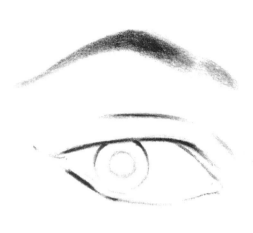

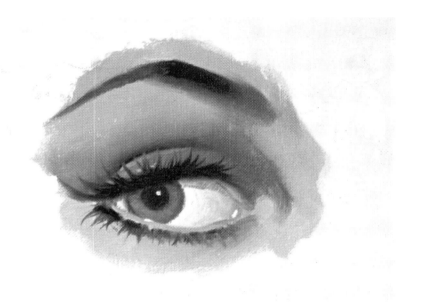

The highlight in the eye should be carefully placed, and it should not be too large. (A large highlight makes the eye look glassy rather than liquid.)

The upper lid casts a subtle (but effective) shadow on the eyeball.

The eyes of your model will never match perfectly. There are subtle differences in everyone's eyes—differences in size, shape of lids, and skin folds. Eyebrows are not identical either, so don't try to make the eyes and brows match exactly. A face that is too perfect is seldom interesting anyway.

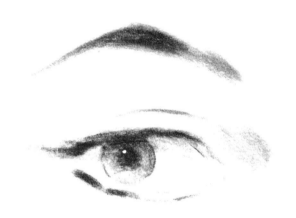

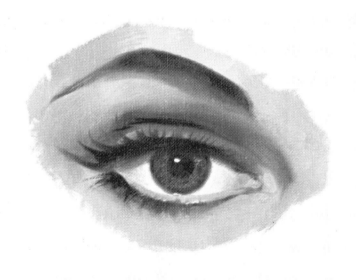

To create the desired liquid look in the eye, put a small highlight in the area where the inner edge of the lower lid meets the white of the eyeball.

Do not make the white of the eye too white; actually, it should be very close to the value of the skin tone.

If your model is in bright light, the pupil of the eye will contract. To make the eye more appealing, make the pupil larger.

The iris of the eye has a soft edge. It is not just a disk of color on the surface of the eyeball; it is an area of color within the eyeball. The pupil also has a soft edge which blends into the iris.

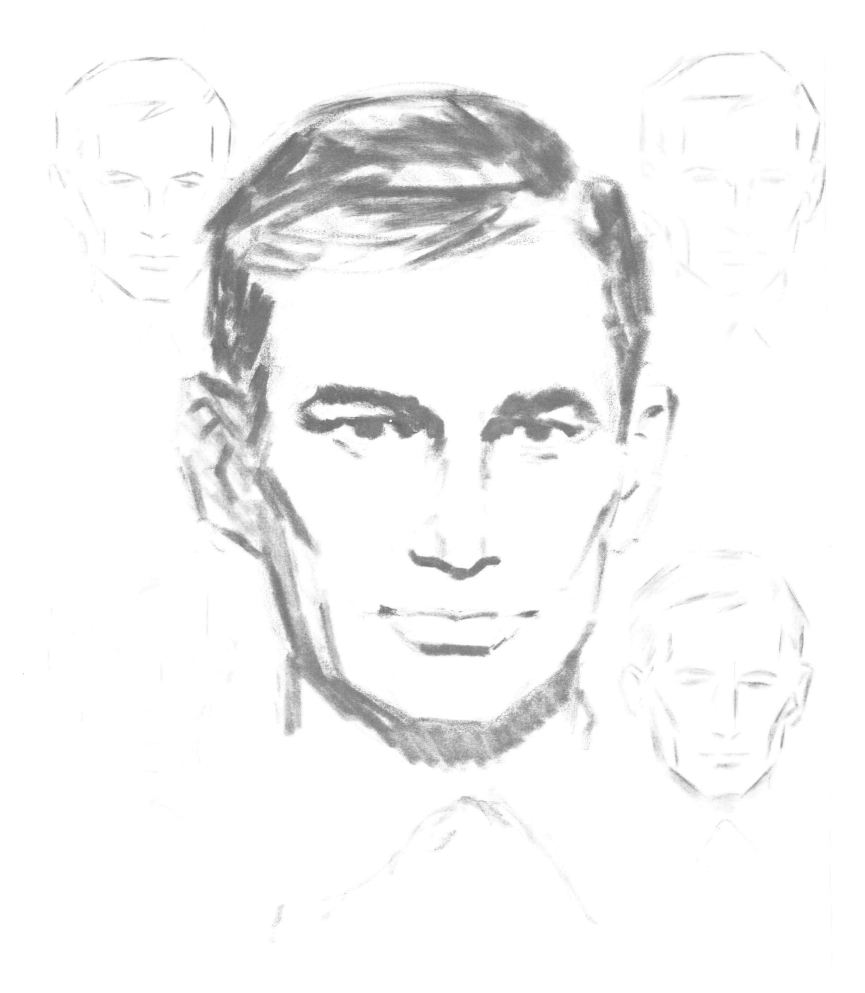

Differences Between Male and Female Heads

A man's head usually has less space between the eye and the eyebrow which makes the eyes appear deep-set. Also, a man's nose and ears are generally larger, the jawline is more pronounced, the brows are heavier, and the bone structure of the nose is more evident. Bolder, more rugged brush strokes will help give a masculine look to your paintings of men.

The skull line of the masculine head is often more pronounced than the female's because of the shorter hair. This is especially true in three-quarter or profile views. Unlike the female head, the ear of the masculine head is usually exposed and must be studied and drawn with utmost care. A badly-drawn ear is the mark of the amateur; a well-drawn, well-painted ear will give your entire painting the look of "authority."

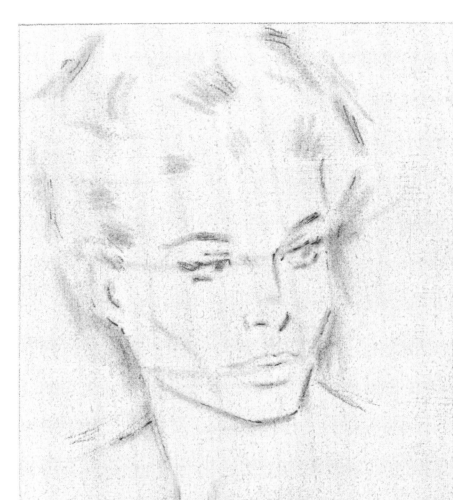

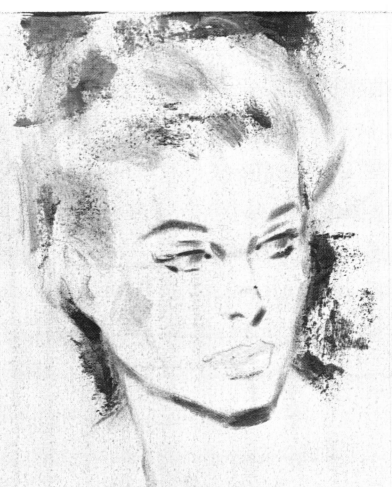

Here the head is lightly sketched on an 8" x 10" canvas board panel and then sealed with several light coats of matte spray fixative.

In this step the features are drawn with a #5 pointed sable brush, and then the hair and background color are applied with a trowel-shaped painting knife.

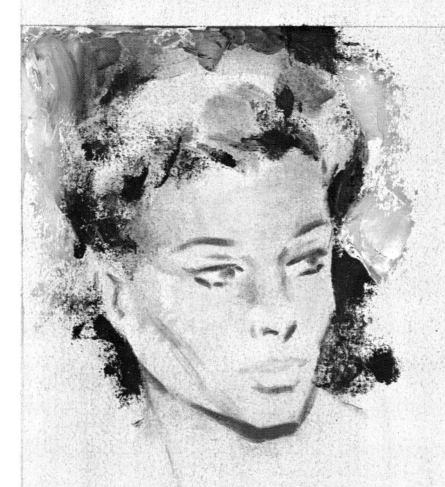

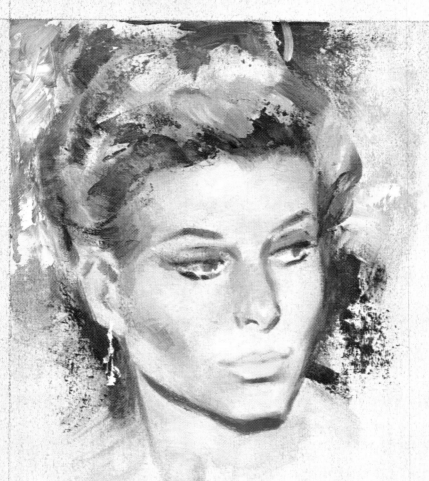

The painting knife is used to add more color to the hair and background. While the brush is easier to control, a painting knife gives a quality of texture that cannot be achieved with a brush.

This is done with a combination of brush and painting knife. The smooth quality of brush work on the flesh is enhanced by the rougher texture of the knife work on the hair and background.

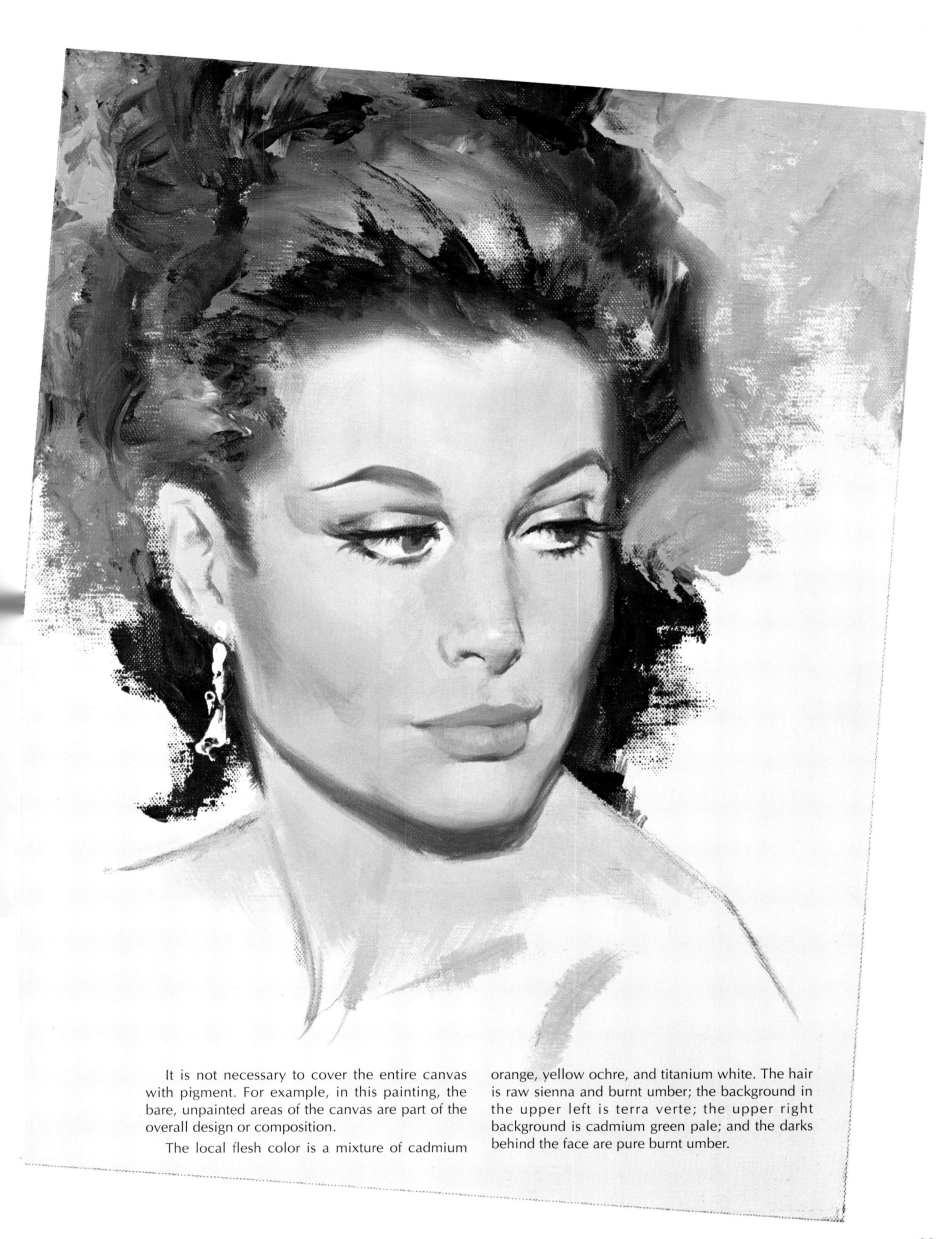

It is not necessary to cover the entire canvas with pigment. For example, in this painting, the bare, unpainted areas of the canvas are part of the overall design or composition.

The local flesh color is a mixture of cadmium orange, yellow ochre, and titanium white. The hair is raw sienna and burnt umber; the background in the upper left is terra verte; the upper right background is cadmium green pale; and the darks behind the face are pure burnt umber.

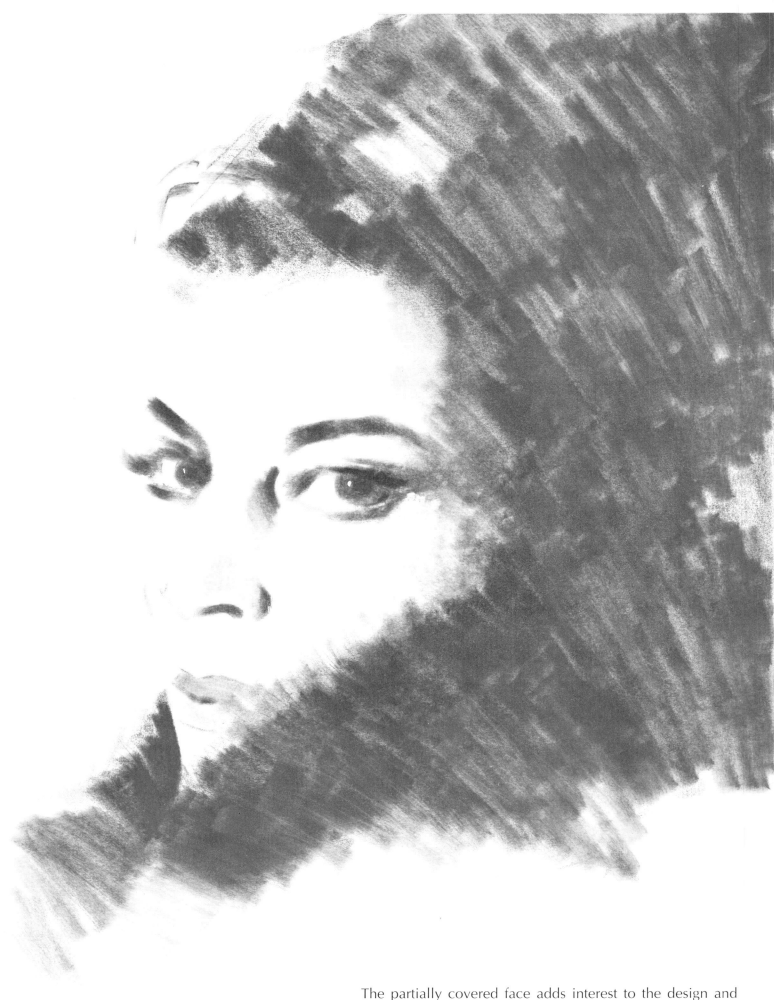

The partially covered face adds interest to the design and composition of this painting. The use of a veil, scarf, or high-collared coat offers many possibilities.

The painting on the opposite page shows the different values of the colors used for the painting on page 1. Value is one of the most important aspects of painting.

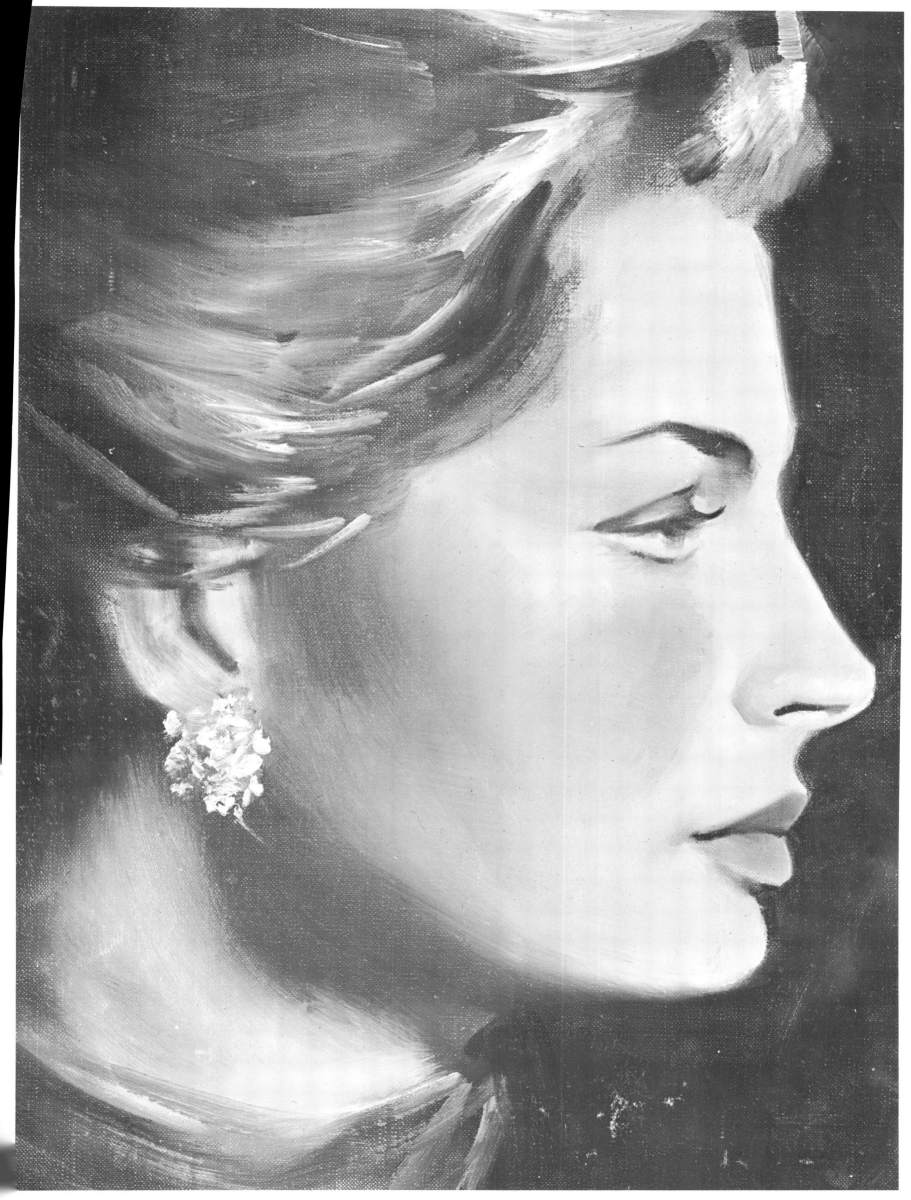

More Ways to Learn

Artist's Library

The **Artist's Library** series offers both beginning and advanced artists many opportunities to expand their creativity, conquer technical obstacles, and explore new media. You'll find in-depth, thorough information on each subject or art technique featured in the book. Each book is written and illustrated by a well-known artist who is qualified to help take eager learners to a new level of expertise.

Paperback, 64 pages, 6-1/2" x 9-1/2"

Collector's Series

Collector's Series books are excellent additions to any library, offering a comprehensive selection of projects drawn from the most popular titles in our How to Draw and Paint series. These books take the fundamentals of a particular medium, then further explore the subjects, styles, and techniques of featured artists.

CS01, CS02, CS04: Paperback, 144 pages, 9" x 12"
CS03: Paperback, 224 pages, 10-1/4" x 9"

How to Draw and Paint

The **How to Draw and Paint** series includes these five stunning new titles to enhance an extensive collection of books on every subject and medium to meet any artist's needs. Specially written to encourage and motivate, these new books offer essential information in an easy-to-follow format. Lavishly illustrated with beautiful drawings and gorgeous art, this series both instructs and inspires.

Paperback, 32 pages, 10-1/4" x 13-3/4"

Walter Foster products are available at art and craft stores everywhere. Write or call for a FREE catalog that includes all of Walter Foster's titles. Or visit our website at www.walterfoster.com

Walter Foster™

Walter Foster Publishing, Inc. • 23062 La Cadena Drive • Laguna Hills, CA 92653 • (800) 426-00